Batik

A Glimpse of the Heart

Caryn Pederson

FOREWORD BY

Steve Richardson

BottomLine

Published by BottomLine Media • ISBN 0-9759997-0-2 • © 2004 by Pioneers. All rights reserved • Printed in Hong Kong, by D.N.P.

Edited by Amanda Sorenson, Sorenson Communications • Cover and page design by Trent Flory, Flory Design, Inc.

CONTENTS

The stories of Indonesians that follow were gathered via personal interview in August 2000 and November 2002. Many names, including names of people groups, have been changed for their benefit.

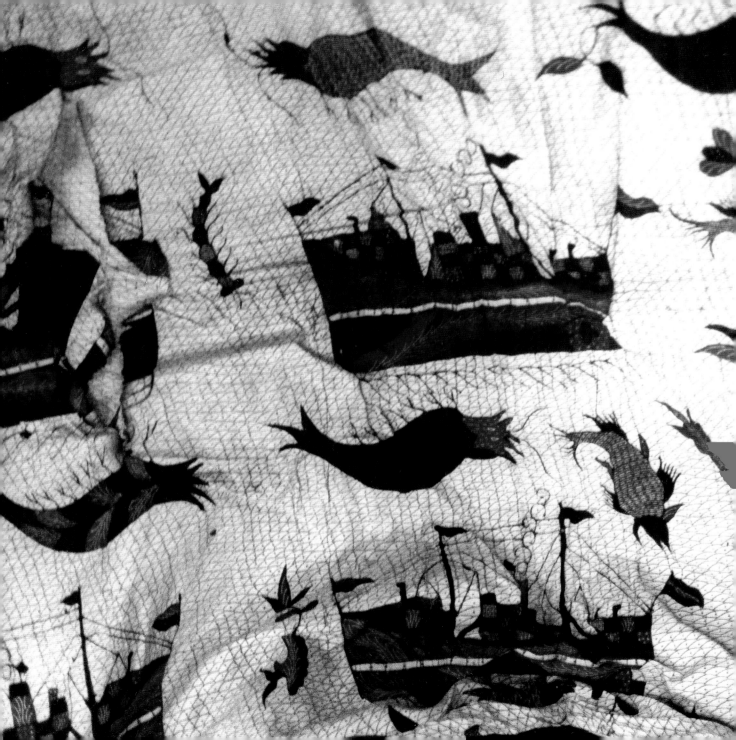

When Columbus "discovered" America, it was a disappointment. He had been hoping to find Indonesia.

And while it may have been the exotic spices that first drew them, early explorers were treated, ultimately, to much more – thirteen thousand emerald islands, ancient civilizations, seven hundred twenty distinct cultures and languages, glaciered mountain ranges and sauna-like swamps, birds of paradise and monitor dragons. They had stumbled on an equatorial showcase of God's unbridled creativity!

For twenty-five years I have explored this remarkable archipelago and interacted with its peoples. What some may consider a finished product, I have come to recognize as a work in progress.

Like the batik for which Java is famous, God's pen is tracing a wondrous design for His eternal glory. Touch by touch, imprint by careful imprint, precious lives are being transformed and given their places in the larger picture of the redemptive tapestry.

Caryn Pederson, herself a photographer and gifted communicator, has taken a few of these beautiful batiks off the shelf and unfolded them for all to enjoy. I know some of the people of whom she writes, and I've heard their stories. Each one is a glorious expression of God's supreme artistry.

—Steve Richardson, President, PIONEERS-USA

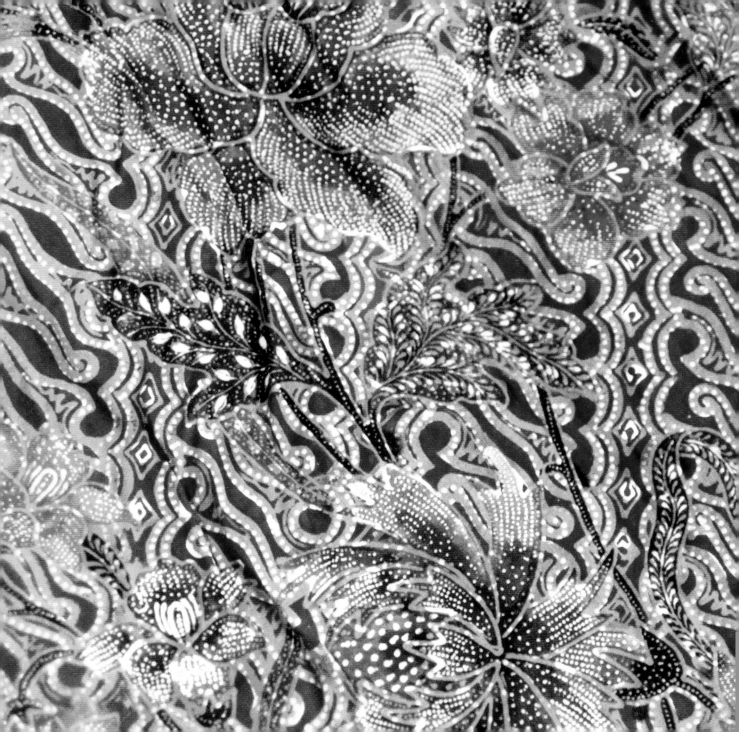

THE HEART OF INDONESIA

Orange, lime green, burgundy, and blue. Fabrics in the tropics wake up our eyes quicker than caffeine. There are almost as many colors and kinds of batik as there are islands in Indonesia. Displayed together, they tell of the beauty, diversity, and heritage of the archipelago. Each batik pattern represents a distinct cultural group, and locals can tell a person as much by the batik he wears as by the first language he speaks. The themes of ships, fish, and waves point to the island of Madura, where life depends on the sea. The bright colors and flowers are from Cirebon, a city known for its artists. A close look at batik gives a glimpse of what is close to the heart.

THE HEART OF GOD

Batik turns our eyes toward God, the Artist Creator, who is carefully and deliberately leaving the mark of His heart on a handful of Indonesians that encompasses all ethnic groups. Each of these individuals bears His signature—the imprint of Christ. The beauty of the heart of these Indonesian Christ-ones is masterfully designed under the heat and pressure of suffering. Their faith, which stands bright against the mosques and Ramadan fasts around them, is the secret to their beauty. Each one is a work of art in process.

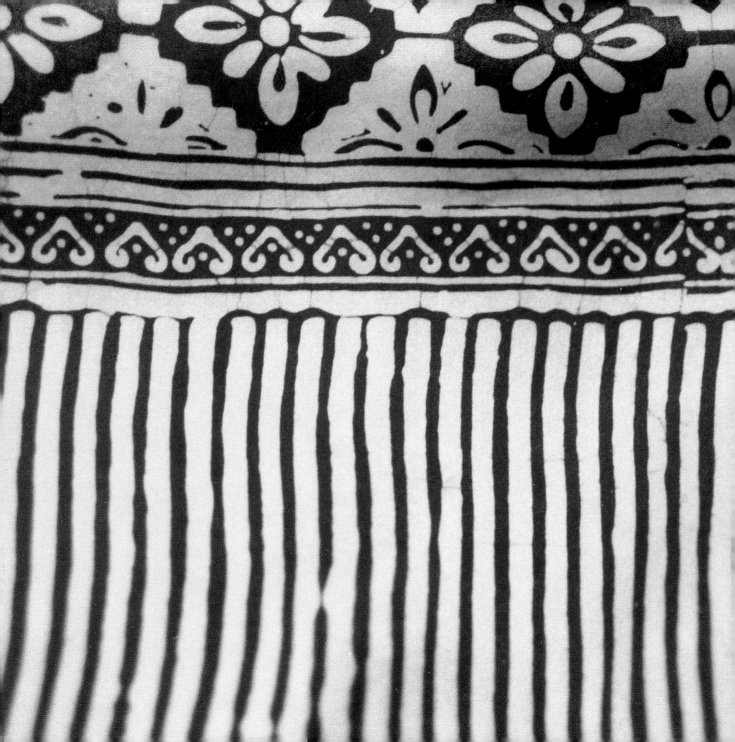

1. CLOTH: BARE AND STARK

Batik starts with a bare cloth. A neutral background allows the artist the greatest creativity. This hand-woven cotton made of handspun thread adds irregular character to the art. Even before a batik pattern is applied, the base cotton canvas is unique.

The artist envisions the end product and pencils gridlines on the work in process. The measuring and marking may seem tedious to the casual observer, but these benchmarks are essential to the beauty of the finished piece. They guide the artist when the waxing begins.

hanafi

Naked, covered in mud, Hanafi stood in front of a mirror and cried out to God. No amount of dirt could convey how filthy he felt inside. He'd committed adultery—with a prostitute, no less. "God, will you take me like this?" cried Hanafi as he faced his sin in the mirror. "I am a very dirty man. Will you accept me? I don't deserve your love."

Hanafi was right. He was undeserving. But he remembered something his grandfather had told him: God sacrificed Jesus so he could be clean. At one time he thought it was funny that a god would do such a thing, but now he understood how his life depended on such foolishness.

The mud, his sin, his

filthiness no longer mattered. Faith gave him a fresh start—just as it had for his great-grandfather, reportedly the first Christian among his hot-headed people, the Madurese. His great-grandfather had told his grandfather, and his grandfather told him. Hanafi, however, couldn't keep the news in the family.

Having stood naked and alone before God, Hanafi stood boldly among his people. Fathers, children, mothers, and grandparents huddled together in the back of a truck headed for Madura, an island that prides itself on being a pure and militant seat of Islam. Space was so tight that no conversation could be confidential.

As Hanafi read Bible verses to himself, he spontaneously blurted out, "What a good God!" A man next to him asked about his excitement. His hot-headed heritage turned to courage, and Hanafi asked,

"Do you want to hear why your destiny is not to perish? Then let everyone on the whole truck hear."

Beginning with creation, Hanafi traced the gospel story throughout Scripture. Some

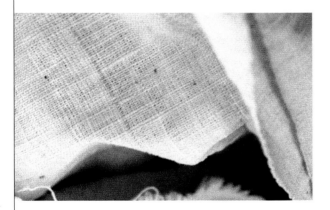

riders grew angry and said, "I don't like Christians," but Hanafi continued. "If God loved you like this and died for you, what is your response?"

After three to four minutes of silence, the most hostile-looking man of the group

raised his hand and said, "I want to receive the Lord." Before they arrived on the island, everyone in the back of the truck believed.

Hanafi's boldness led to an encounter with the local authorities because Indonesian laws prohibit proselytizing. But after several days of questioning, the officers released Hanafi. They were unable to find fault in his answers about Islam and Christianity. As he was released, the officer demanded, "Do not tell the Madurese about Jesus."

"Do you own the Madurese?" asked Hanafi. "How can you say that when I myself am Madurese?" Hanafi spent the next year on the mainland of East Java, but when he returned to Madura a year later, he found that the first man to come to Christ was leading others to do the same. Hanafi's example had given him a bold grid mark to follow.

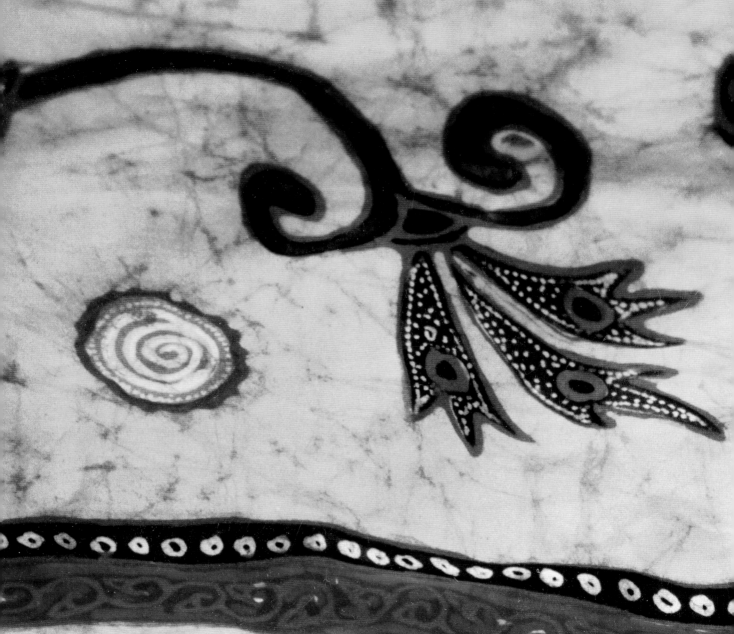

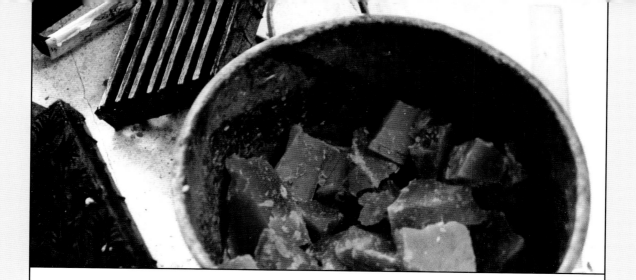

2. WAX: BECOMING USEFUL

In an open-air room crowded with waist-high work tables, a pan of melted wax sits on a wooden, one-foot square stand. Next to the stand is a pot containing hard chunks of yellow-brown wax. These rough-edged pieces are essential to the art of batik, but they are useless in that form. Only when the chunks are added to the pan and subjected to the heat of the coals below does the wax become useful.

Luh Sri

Luh Sri had it made. Even during a time of economic crisis, her family could afford to send her to college. Through that education, Luh Sri overcame the stigma of being a minority—a Hindu in the most populous Muslim nation in the world. She learned courage early, but the comforts she'd known at home kept her rough on the edges. She had too much raw potential for her to stay that way.

"What happened to you?" asked Luh Sri's mother.

"I've changed my faith," answered Luh Sri, the oldest of two girls in her family.

"Is it because of your boyfriend?" probed her mother.

"It's not because of friends," she answered with a new boldness. "God chose me to be His."

"Do you want to continue to study or to follow your new religion?"

"I want to do both," answered a girl accustomed to being spoiled. "But if I must choose, I choose my new religion." The rough edges began to soften. Things weren't going her way.

When her family would no longer pay for her education, she went to work as an English teacher and interpreter. Each job took her away from her family and presented her with new challenges. Sometimes there were new friends who also trusted Christ and could help her learn how to follow Him. But at many other times, she was left to stand alone. Despite being taunted by others for having three gods (in the Trinity) instead of one, Luh Sri admits with a smile, "It is grace to be suffering." She knows it is reshaping her and making her usable.

3. BATIK CAP: IMPRESSIONS THAT HURT

A sharp, metal stamp several inches wide and about two inches tall has an intricate pattern of flowers, animals, or ornaments on one side. On the opposite side, an arched metal handle is wrapped with a finished scrap of batik to protect the artist's hand and offer a reminder of what is to come.

The stamp is dipped into a pan of melted wax, allowing the liquid to come halfway up the side of the stamp. The artist then presses the tool firmly onto the cloth. After steady initial pressure, he gives the handle two firm taps to evenly distribute the wax. This technique is *batik cap* (pronounced "chop")—literally batik "stamp." It comprises the bulk of the batik made and sold.

nadeem and May

Nadeem and May stood in silence in front of the chanting crowd. "Get out of our village. If you don't go, we'll burn your house down." The shouting awakened three-year-old Rita, but before May went inside, she and Nadeem prayed, "Help, Lord!" They could think of nothing else.

God had led them to this small island village. They had worked hard to build relationships and credibility in the community, but after two years of slander and lies, the persecution had escalated beyond misperceptions. "What is my problem with this community?" asked Nadeem. He hoped to make at least as strong an imprint on the crowd as they were making on him. "Did I steal something? Did I rape someone? What is the problem that you should come tonight? Tell me and we'll meet tomorrow to discuss it in the governor's office. Go home and think. I helped build the mosque and other things in the community. You don't like Christians but you like Christian things.

"We're not leaving. If you want to burn this house down, you'll have to burn us in the middle of it. We're trying to teach people to do good things. I know your religion doesn't teach you to do this. If you want to talk, come in and we'll have coffee and tea."

One by one, people left. The couple stayed. Months later, however, they were warned to run for their lives. Militant Muslims were approaching. They fled with their daughter, but due to a rain

storm, they stopped to hide in a shack in a rice field.

May knew God had protected them before and he could do it again. But she and her husband and daughter were hiding in the middle of a rice field. It was pouring rain and they were being forced out of their village. Little Rita's cry, "Mommy, I'm hungry," shattered whatever composure May had left. She was tired, wet, and unable to do the most basic thing expected of her. She could not feed her daughter. She wept.

While tears were still on May's cheeks, a villager, one of Nadeem and May's friends, walked by the shelter. They never learned why he was out for a walk in the rain that evening, but he brought them safely to the home of another woman who provided dry clothes and lodging for the night.

Nadeem and a friend planned to return to their home in order to grab the family's birth certificates and diplomas—essential elements of life in Indonesia, but Muslim activists were too close. Camouflaged in a truck—Nadeem under a pile of vegetables, and May under a Muslim head covering—the couple escaped to a safer area. They arrived alive, but like batik in process, the heat and pressure had left their mark. A pattern has been established, and the process will bring out beauty in time.

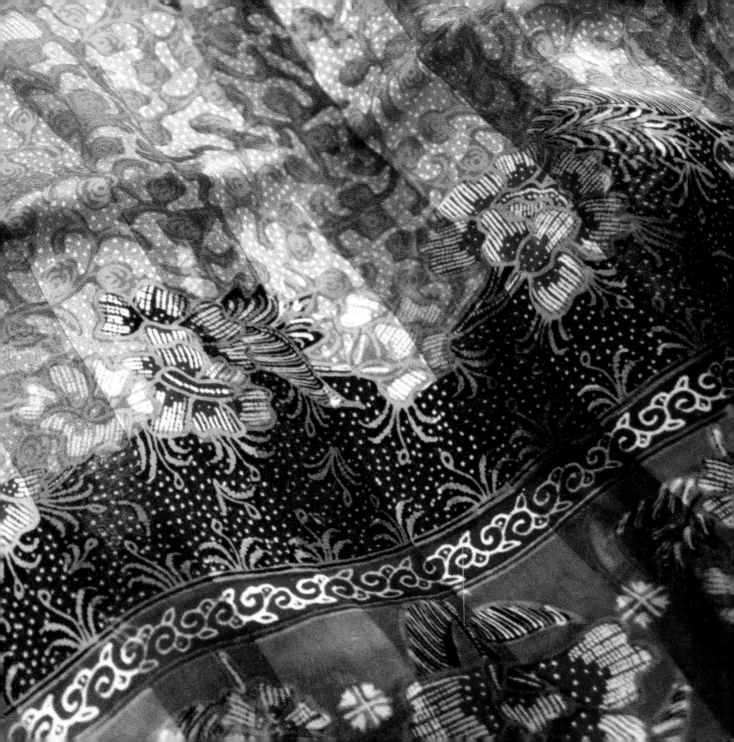

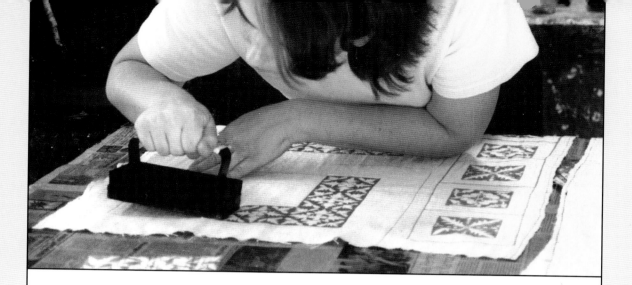

4. REPEATED STAMPS: REPETITION SHARPENS BEAUTY

As the stamped wax application begins to dry, the process begins again. The artist carefully puts a second stamp down precisely on top of the first one—without blurring the edges. Without this extra step, dye may bleed into the white fabric. The additional wax keeps the colors crisp, the contrast sharp. Repetition reinforces the pattern and enhances its beauty.

rakMad

Rakmad's family formed a tribunal to prove he had become an apostate. Once they verified his rebellion, they could cut him off. A week earlier, Rakmad's brother-in-law had put a sword to his throat and threatened, "If you ever ask my sister to become a Christian, this sword will cut off your head." For now, his relatives just planned to cut him off from the family.

Rakmad was excited. He'd been following Jesus for a few months, but none of his family had inquired about his new beliefs. He was eager to answer their accusations and hoped that their dialogue would reveal Christ as the true God. He sat in the center of a circle, surrounded by extended family. All eyes were on him as his wife read aloud his defense, the reason he'd become a "heathen," which is what his family had called him ever since he decided to follow Jesus.

When given the opportunity to speak, Rakmad encouraged them, "Empty your mind. Imagine we're hearing a lecture on comparative religions. We're going to look at each religion objectively and pretend we have no religion." He knew his father and uncle were familiar with such discussions.

Rakmad used the Koran to explain his new position. The faces of his family members showed clearly that they were thinking deeply about what he said. He stirred so much thought that they decided to meet again a month later to continue their discussion and reading of the Koran.

After the second meeting, the family elected Rakmad to coordinate the next gathering. The accused one agreed, and in time he began introducing songs and liturgy patterned after those at his church. The songs based on the Holy Bible became the family favorites. But the family gave up meeting when they realized Rakmad was changing their minds, not the other way around.

Three family members became believers, but even they will not speak with Rakmad in public. When he gives a traditional holiday greeting, they refuse to answer. Family and community are so highly valued in Indonesia that if you are not part of a group, it is as if you don't exist. Being snubbed cuts deeper than a sword ever could, but it cannot darken the gleam in his black eyes as he talks about his faith.

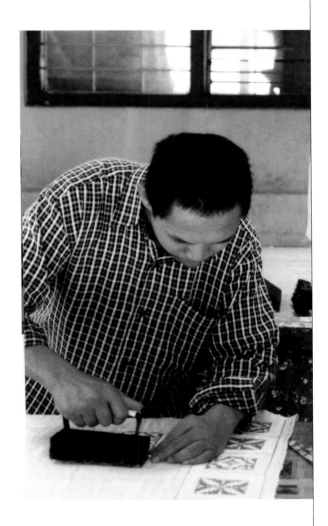

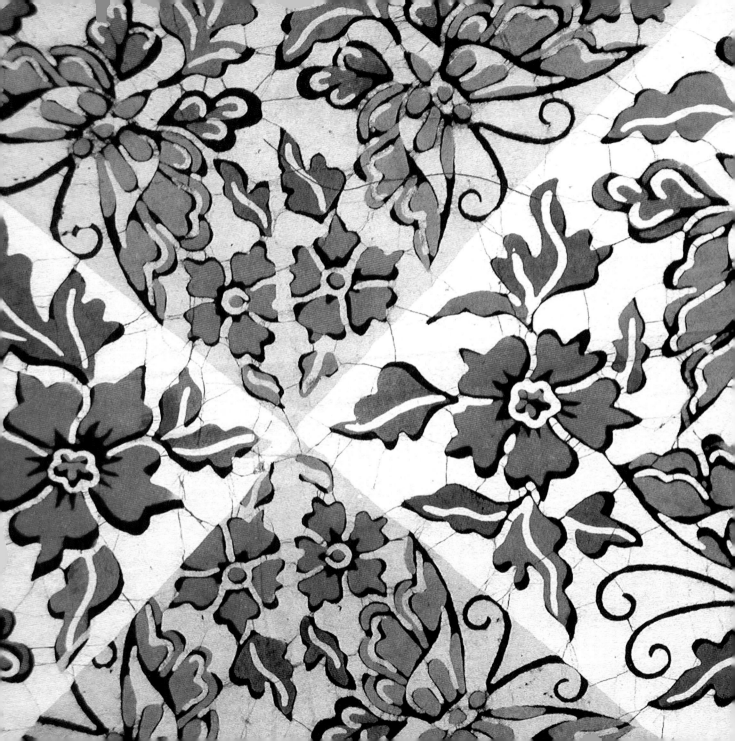

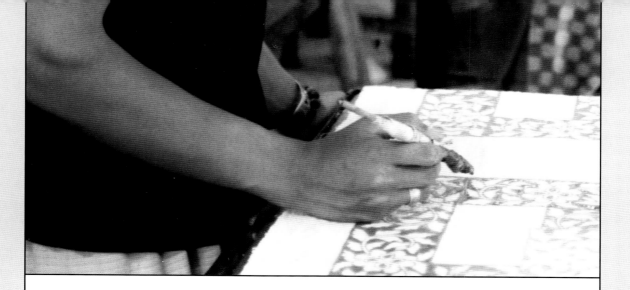

5. GAPS IN WAX: MISTAKES

*O*nly the trained eye can look at piece of finished cloth and see the "blocks" in an apparently continuous pattern. If there are any gaps between the stamped sections of wax, the artist fills them with the end of a stick dipped in wax. If he succeeds with this "white-out," no one will notice his error. But if he doesn't, an occasional line mars the continuous pattern and reveals the stamp technique to all.

rukan

Rukan was nineteen, a newlywed but "good for nothing." Life as it ought to be was betrayed by the reality that she was her husband's second wife—his mistress in a different city. Never would she have the affection of a first wife. The love she thought she had was all a lie. Pregnant and soon to be divorced, she was damaged merchandise.

Defying the stigma, Rukan set out to raise, care, and provide for her son on her own. Child support in Indonesia is rare. Rukan had only a third grade education, but she had a mind for business. First, she bred rabbits and guinea pigs for a profit. When this ran dry, she moved from her village to the city. There she began working as a helper for foreigners, but her first employers dismissed her and would not give her a recommendation. Hurt but not helpless, Rukan had an ingrained courage and soon began working for another family.

In a culture that is keen on pleasing others, Rukan would stick up for what was right, even if it meant making others angry. She would be honest with her boss when other helpers were dishonest. She would stay late to finish a task rather than leave a job undone. She even began sharing her skills in breeding rabbits and guinea pigs at her new spot in the city.

Rukan eventually was employed by missionaries Steve and Arlene Richardson. She quickly gained their trust and began looking after their children in addition to her usual duties of cooking and cleaning. So it was natural that Rukan was present when "the box" arrived.

Inside the box was a quilt pieced together from fabric scraps Arlene's deceased grandmother had owned. Arlene was delighted to receive this remembrance of her grandmother. Rukan, who had spent her life in the tropics, had never seen a quilt before. Fascinated by it, she borrowed the novelty for just a few weeks and came back with another quilt she had made. The colors were Indonesian (alarming to a North American), but Arlene looked past the clash to the potential.

Under Arlene's guidance, Rukan and members of her extended family began sewing quilts to sell to foreigners in the area. Arlene and Rukan dreamed of export and what the business might become, but Arlene got hepatitis. Unable to sleep at night from the itching, she often sat in the living room and quilted with Rukan. As they hand stitched piece after piece of blue fabric, they fell into deep spiritual

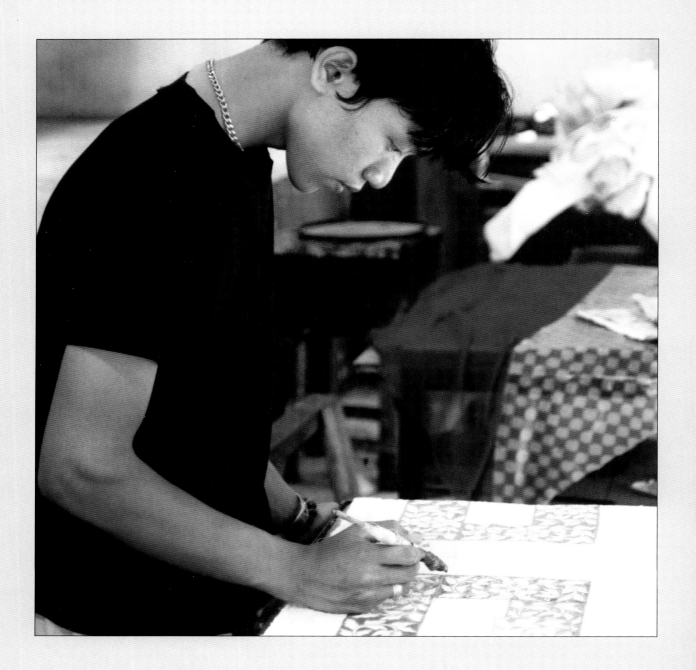

conversations. One evening they watched the *Jesus* film and Rukan cried. She loved the story, but knew that following Jesus would cost what she was not yet prepared to pay. Her husband had left her. Former employers had chased her away. She wasn't sure she could handle losing her family—an inevitable consequence if she chose to believe.

Spiritual issues aside, the quilting idea began to grow. Rukan's family invited members of their village to join them, and soon the Richardsons had squatters in their backyard. The quilts sold well in America and profits soon provided funds for a building. HeartCraft, the new quilting company, provided jobs to people from fifteen different villages and allowed employees to live in community with other employees—the majority of whom were Christians.

Years after HeartCraft was established and Arlene had moved away, Rukan needed cash. She had always been a woman of integrity, but she altered a receipt and pocketed the difference. Her supervisor suspended her and cut her salary. Rukan wept—not because of the consequences but because of her wrongdoing. In the past she had suffered because of someone else's wrong, but now she had done the wrong. The upright Muslim saw her sin.

When she mentioned the situation to Arlene a few months later, Rukan expected another rebuke. Instead, she found grace. Arlene saw the change of heart in her former employee and said, "In the eyes of the world, it was a bad thing, but spiritually, it is good." Within a year, Arlene received another call from Rukan, her dear friend, and finally, her sister in the Lord. Any gaps or breaks in the pattern have been filled in perfectly.

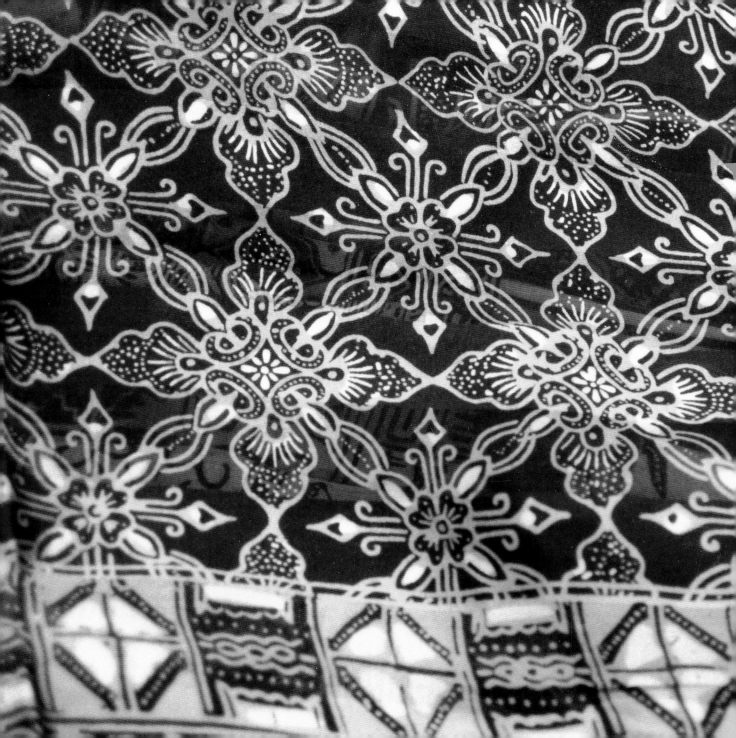

6. BATIK TULIS:
LITTLE DETAILS PROVE IMPORTANT

*D*espite the twelve or more hours it takes to do one piece, batik cap is commonplace. Street vendors sell it. It is the bulk of the stock in a batik store. But tucked away in a corner cabinet is a hidden treasure, the *batik tulis*.

In this variety of batik, the wax is applied with a pen-like tool. (Tulis means "write" in Indonesian.) From a small, metal well, a single tip of hot wax is slowly, deliberately drawn across the entire piece. The same tool is used to print staccato dots across parts of the pattern. The process is long, and the price is high for such custom work, but batik tulis is batik at its finest.

Kardi

A third grader handed over his one-cent piece and sat down to enjoy his boiled peanuts. While he enjoyed the snack, he read the wrapper. Partway through, he realized he was reading a page from the holy book of Christians.

It spoke of Jesus, the prophet he had studied, being crucified. He was curious as to why: had the prophet had committed a crime? Kardi wanted to learn more but had no way to do so at the time. Yet those few, well-placed words made a lasting impression.

At age 15, Kardi went to an Islamic school and wondered, *Is my religion true, or is it empty and worthless?*

Every Friday, he faithfully went to the mosque. He said his prayers five times a day and followed the pillars of Islam, but he still wondered, *Is it true?* None of his Muslim teachers had been able to answer his questions about the prophet Jesus.

Kardi later helped welcome some foreign visitors to his city. He asked one of them where he could learn more about Christianity. "In what language?" asked the visitor.

Utterly amazed, Kardi gladly received the Scriptures in Konahare, his first language. After years of studying Muslim teachings in Indonesian and Arabic, still with no answers about the prophet who was crucified, the foreigners offered answers in the language of his heart. "I read the whole Bible, and my whole family read the Bible," he says. "My whole life changed."

Kardi tells of the change with joy, but not everyone in his village shared his enthusiasm. Some of his friends poisoned his pond so he could no longer eat his fish. They put manure in his well. They refused to help him when it was time to harvest rice. No longer able to provide for his family, this new believer began selling pots and pans.

Like a single line of wax trailed across a cloth, Kardi traveled from village to village to market his wares. At door after door, he found the opportunity to tell people what he had discovered. Without realizing it, Kardi began to live what he read about in that holy book. After he'd been harassed, just as Jesus' friends were, he, also, went "house to house teaching or proclaiming the good news" (Acts 5:42). Many believed, and today, countless Indonesian believers trace their spiritual heritage back to someone Kardi led to Christ.

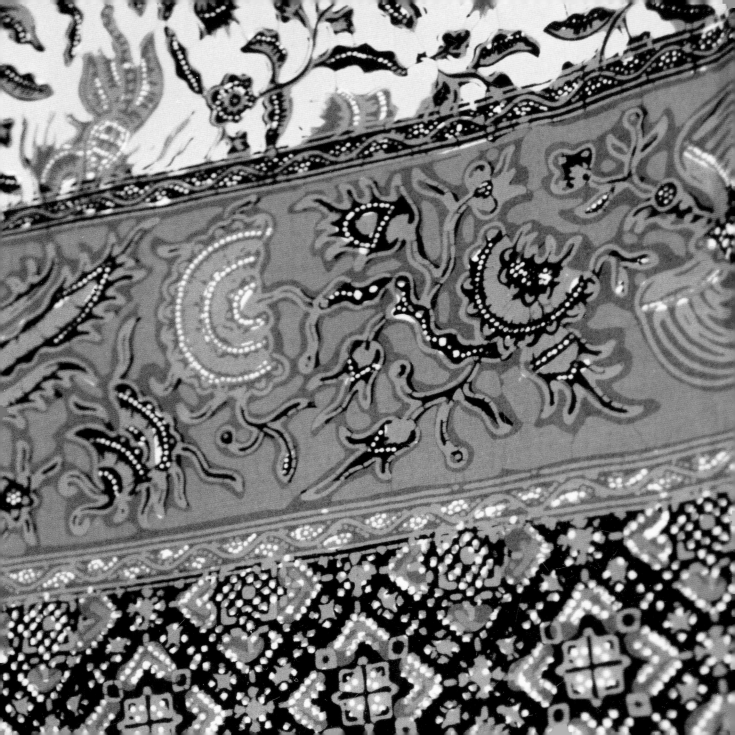

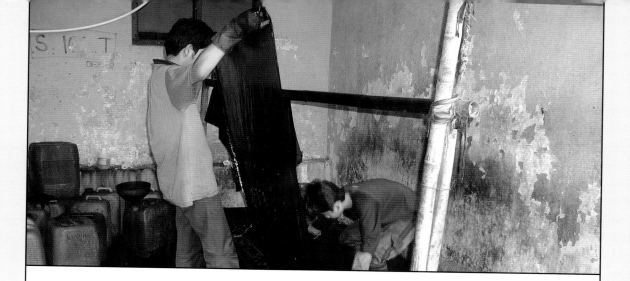

7. DYE: EARLY STAINS STICK

After the wax, it's time for dye. Two young men wearing rubber boots and gloves place the cloth in a vat of dye. Each one takes an end of the cloth and pulls it up and down, in and out of the long, narrow trough at their feet. After repeated immersions to ensure an even color, they hang the piece to dry. To the careful observer, a beautiful, three-dimensional wax pattern of blue on blue hints at the beauty below.

iday

Iday's wide, six-year-old eyes tried to soak it all in. All the neighborhood leaders stood outside, cursing his grandfather who was also a local leader. His grandfather, his hero, was being called horrible names. Iday didn't even know what words like "apostate" meant, but it sounded bad. His forehead wrinkled in confusion. His grandparents had raised him to say his prayers five times a day and to read the Koran. His grandmother had taught these things to the whole village, and his grandfather had led the Islamic ceremonies at the rice fields. Why were the people lashing out at their leader?

Iday learned that his grandparents had recently trusted in Jesus and that followers of this prophet should expect such treatment. So for the next week and a half Iday's grandfather was called into the police station two to three times a day. Over and over again, officials immersed him with questions about his faith in Jesus.

The grandfather's decision affected the whole community. No one prayed blessings over the rice plantings, no one taught the children the Koran. While the village remained adamant, Iday's grandfather and grandmother remained strong in their new faith. The ongoing harassment made them even stronger. Watching it strengthened Iday, too.

After moving away to go to secondary school, Iday ran out of money, so he quit school and started working as a milk boy. With canvas bags strapped across the back of his bike, he would pedal through neighborhoods, delivering bags of homogenized milk. One of his customers, the

Dixon family, learned of his spiritual interest and offered to send him to Bible school. While he was in school, a pastor encouraged Iday to work with his own people, the Konahare. At the time, less than .3 percent of the Konahare were affiliated with any church.

After graduation, Iday began working with the Konahare people through a Chinese church. Ten years into this ministry, Indonesia faced a major economic crisis. A third of the population suddenly couldn't afford to eat three meals a day.

Economic difficulties had brought Iday to the Dixons' doorstep, and now a financial crisis had created another opportunity. A church in Maryland had taken a special interest in the Konahare and offered to buy a building for the Konahare congregation if Iday would be its full-time pastor.

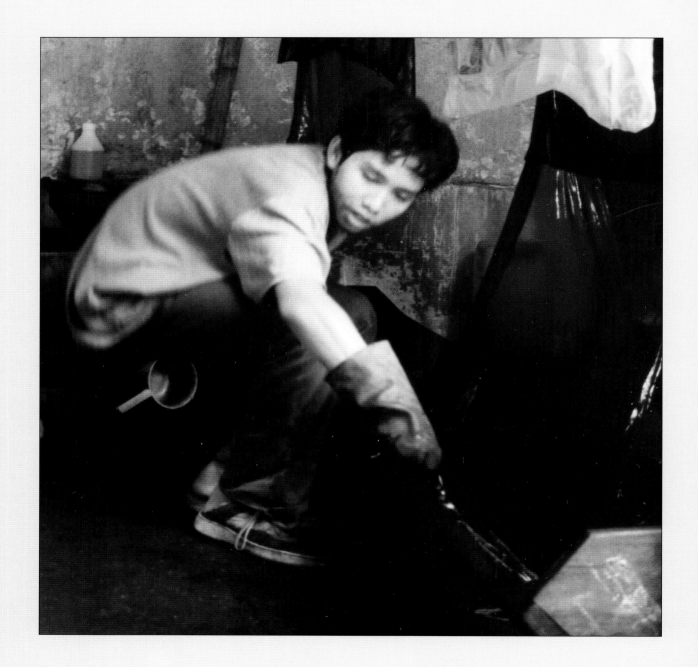

For weeks Iday weighed the decision. His association with the Chinese church provided financial security and status. As a full-time pastor of the Konahare, he faced poverty. He loved his people but knew from his vivid memories of delivering milk just how poor they were. Could God still provide for his family, now a wife and three children? Following the example of his grandfather who believed when others would not, Iday plunged in.

Two months into the new assignment, Iday's nine-year-old daughter ruptured her appendix and had to stay in the hospital six weeks. She recovered, but the bill for her medicine and hospitalization was equivalent to two year's salary—at the Chinese church! His meager savings made only a dent in their debt.

Shortly after that, Iday received a royalty check for some original Konahare songs he had given to a music producer, for which he never expected payment. Yet the surprise arrived just when they needed it. Through this and the generosity of others, more than 85 percent of the bill was covered by Indonesians.

"They wouldn't have given if he hadn't been doing Konahare work," noted one of Iday's missionary colleagues. "They gave because they believed in what he was doing. The Lord waited for Iday to make the decision in faith. And once he took the risk, God showed Himself faithful."

So Iday continues, stepping into each new challenge. Today his church meets in an office building with no back door. If a radical Muslim mob came in to loot and burn, he and his congregation could be burned alive, but the church continues to meet. "Our lives are in God's hand," says Iday with a warm smile. "If we die here, we live in heaven."

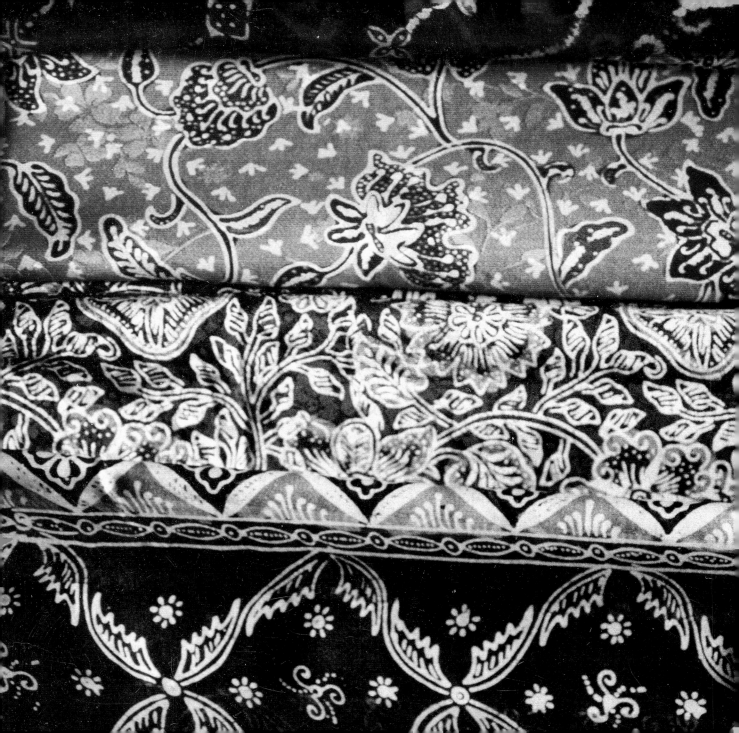

8. PAINTING: COLORS OF COURAGE

If more than two or three colors are desired in the cloth, another step is added between the waxing table and the dyeing trough. The waxed crème cloth is spread across the concrete floor of an open air room. The stiff imprint of the wax outlines petals, leaves, and ornaments that trigger creative possibilities. A bamboo stick is dipped in dye, then applied to these small gaps in the wax.

Carefully, the artist colors one ornament at a time. With dye the consistency of watercolors, it would be easy for a spot of green to

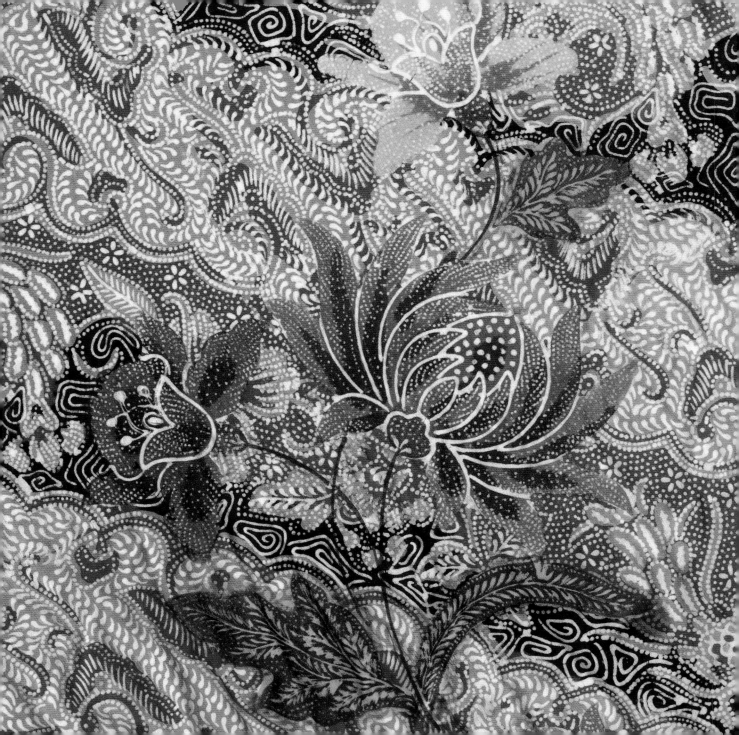

drip onto the yellow, or a spot of purple to darken the red. The work in progress only hints at the finished product, but the knowing artist trusts that though the dye looks odd now, it will be the right accent in the end.

When this detailing is done, the cloth is dipped in acid to seal the colors. Then the waxing begins again. A reverse of the first wax stamp is applied over on the hand-dyed areas, creating a solid mass of wax. This preserves the bits of orange, red, yellow, and green that will be submerged in the dark blue dye.

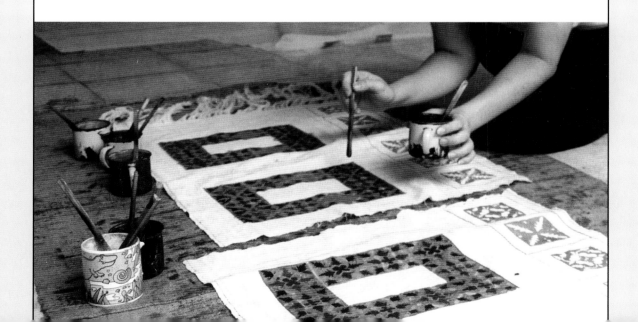

putu and teti

When he left home for Bible college, Putu packed two sets of clothes and one pair of shoes—nothing more. He had no bar of soap or toothbrush to complete the package. As Putu says, "All I brought with me was my courage." That courage held out until he was able to get a scholarship.

While at school, Putu met and married his classmate, Teti. Shortly after their first child was conceived, the two left school. Life was hard. Spots of color were being laid down, but they didn't look quite right. The pattern was confusing. Putu served as a pastor at a comfortable church where members had little vision beyond themselves. His responsibilities kept him away from home from 5 a.m. to 10 p.m. with only a brief, midday break. Teti, who had recently finished five years of Bible education, spent all day in a tiny apartment with their newborn. The newlyweds had no time together except to fight. Yet they believed the Artist was at work. He alone had the vision. He alone knew what the colors would become.

Eventually Putu left his position at the church and returned to school to finish his five-year Bible degree.

At school this second time, Putu heard a missionary speak about an island of more than 60,000 people, yet not one Christian. He couldn't shake the thought, so he began to pray. Before long he admitted, "I go to bed and I think about the island. I wake up and I think about the island."

Although the island is notably hostile to outside religious influence, Putu and Teti have moved their young family to this difficult place in order to share Christ. Once again, all Putu brought with him was his courage. Once again, the Artist is applying new colors. Will the end result be worth the price? Wait and see. Ask the people from this island who will trust Jesus because Putu and Teti came.

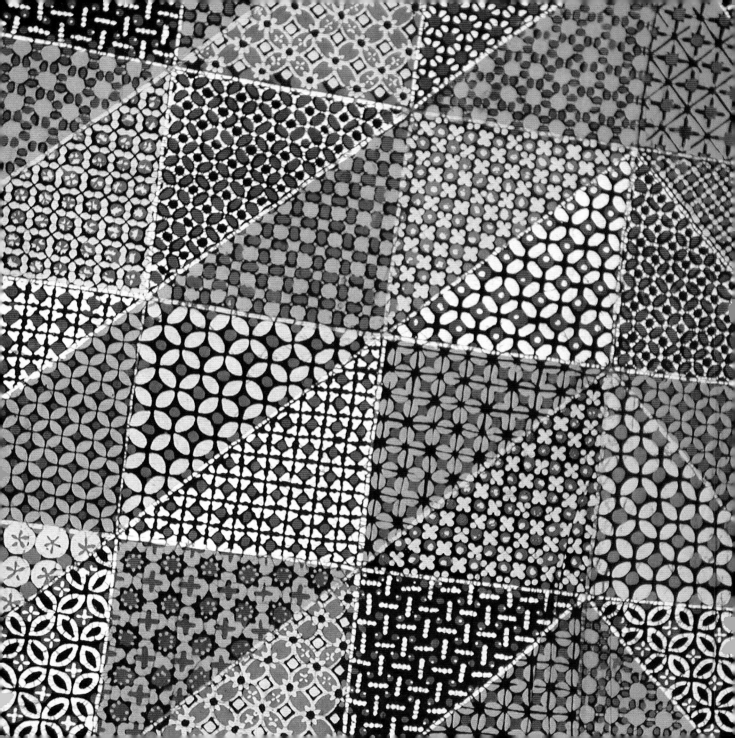

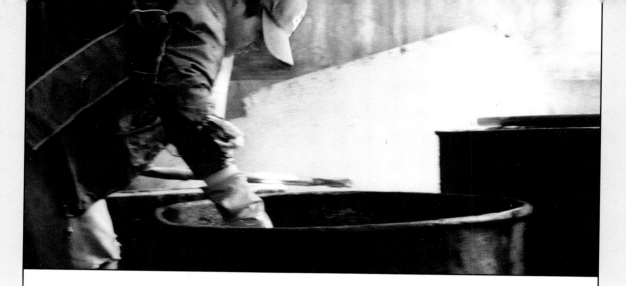

9. BOILING OFF: A REVERSE REVEALED

After tropical breezes have set the dye, the cloth is plunged into a kettle of steaming water. The one who dyed the cloth now stirs it with a stick to let the water penetrate the fabric and loosen every bit of wax from the cotton. Open slats in the ceiling allow the steam to escape and sunlight to streak in—a visual drum roll to unveil each new piece of art. When the stirrer removes the piece, the pattern is clear—even to those who couldn't envision it along the way.

istatik and islilik

A chorus of children chanted the lesson back to their teacher. "Karma perala: Success in life affects reincarnation… only the perfect enter heaven."

The guru taught her students that if they were bad, death would bring them back to life in a state worse than their current one. But if they were good, they would reincarnate as something better. Only the perfect enter heaven.

The teaching haunted Istatik. Every day she trained young minds in Hinduism at the Ngadirjo Elementary School. In her heart, she knew that the reverse was true: only the repentant who believe in Christ's perfection enter heaven. Each day she had to reinforce karma perala, and each day she wondered, *how can I keep teaching this lie?*

Still, Istatik kept teaching. Her parents' agricultural business was struggling. They'd sent her away to become a guru in order to help the family socially and economically. Their whole village counted on her to teach the next generation of children the principles of Hinduism, and her parents counted on her income. But Istatik knew things had to change.

She began asking God to give her another job, and before long Istatik took a job in

a city 300 miles away. Her letters home brought a whole new world to her village. HeartCraft, the factory where she worked, made quilts and handicrafts to sell to tourists and for export. She wrote of the big room filled with forty sewing machines all working at once. In other rooms she joined other ladies in hand-stitching cloth stretched taut across a sewing ring. In one corner, just above the floor boards, slashes in permanent marker read like inches on a wall-sized ruler: twin, full, queen, and king. These marks guide those who cut the quilt backings to size.

Although intrigued by these accounts, Istatik's younger sister, Islilik, was most concerned about finding a job. One Friday evening, she returned home discouraged by her job search and sensed the Lord saying, "At 7:30 Monday morning you'll receive a call." At the same time she wondered, *Was this God's voice, or my own?* She received

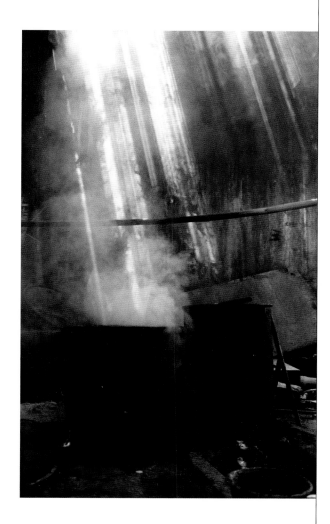

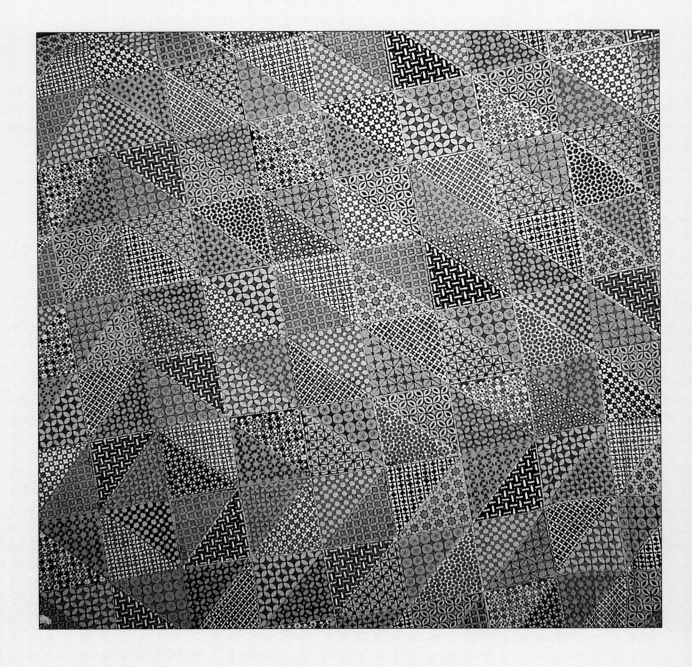

the call exactly as she'd been told. Could Islilik come and work at HeartCraft, too? She still cries when she remembers God's willingness to answer her prayers so directly.

Islilik joined her sister. For four years they lived together in a tiny room and shared a single mattress so they could send 75 percent of their earnings home. Eventually they brought their parents out of bankruptcy. As they worked alongside and grew in friendship with other Christians, God called them to go to Bible school. With their education complete, Istatik and Islilik are looking for ways to share their hope with those stuck in Hinduism.

One way they tell others about their faith is rooted in the history of their people, the Tenggarese. Legend has it that when Islam first entered Java and the Hindus fled to Bali and the area surrounding Mt. Bromo,

the first couple in the area, Ten and Ger, asked the gods for children. The gods agreed, but only if the couple would sacrifice one of the children to them. The couple eventually had twenty-five children but couldn't decide which one to give up. So the gods grew angry with Ten and Ger for failing to keep their part of the bargain. The volcano began to rumble until the youngest son volunteered to be thrown into the cavern of Mt. Bromo. His sacrificial death brought an end to the tremors and saved their valley.

Istatik and Islilik use this legend to point out the greater love of a Son who sacrificed Himself for the whole world. Although Istatik's days of teaching the karma perala are over, the Mt. Bromo tale with its hints of God's eternal plan is worth repeating.

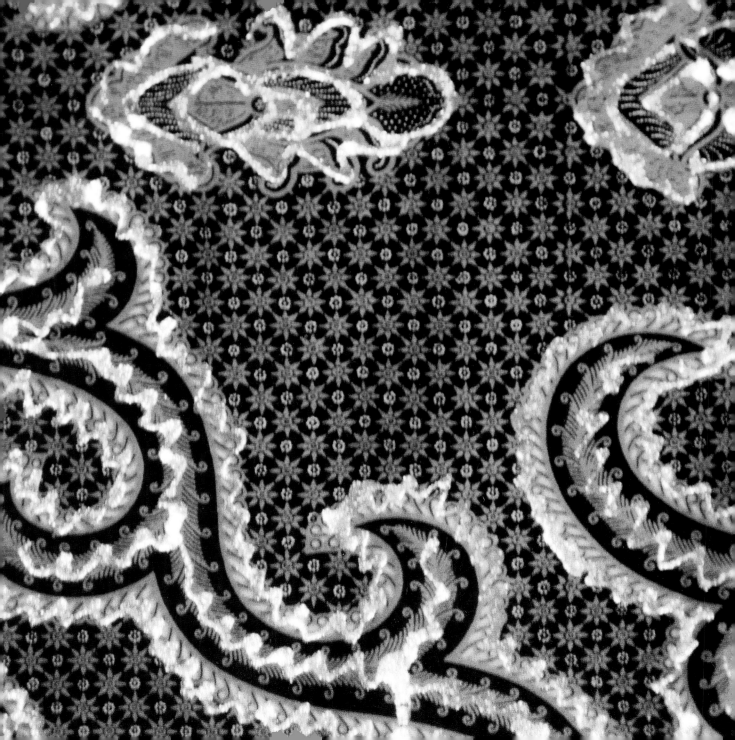

10. GOLD: A CROWNING TOUCH

After batik is waxed, painted, dyed, boiled, dried, and even pressed, a few choice pieces receive the finishing touch of a gold wax accent. The detail is added on top of the pattern with the same tool used in batik tulis. The detail makes a piece shine and stand out in a stack. It is not for all batik, but it is the crown of the art.

nella

Nella did not know it was her night to die until she got to work the next morning. This petite Indonesian found the head of a bird lying on the floor as she left her bedroom. She thought little of it, but as she rode to work, she realized that the bird outside her door matched the bird in her dream. A ghostlike figure with the head of a bird and the body of a boy had tried to strangle her. In defense, Nella sang, "Jesus, you're a good shepherd." As she sang, the figure left.

"Thank goodness you're alive!" said a Muslim coworker who went on to explain that on four occasions someone had paid to kill or curse Nella

through black magic. This practice is common on their island where religious beliefs are a blend of Islam and animism.

Nella was too fun-loving to have many enemies. As the only Christian teaching in a Muslim school in the largest Muslim nation in the world, however, Nella was clearly a minority. Her supervisors feared she was trying to "Christianize" her students; her coworkers wanted her dead. They had no evidence, but they appealed to the department of religion as well as the local shaman to try to remove the threat.

When the government official asked Nella to report to her, she and a mentor studied and prayed over Matthew 10: "When you are brought before governors…do not worry about what you will say." Nella found God's promise to be true. The Holy Spirit gave her answers that silenced the accusations. The next time someone

tried to hire the shaman to curse or kill her, he refused, saying, "She's got a power I can't touch."

The shaman couldn't touch Nella's power, so the school opted to wield its own. Nella was asked to leave, so she began tutoring clubs in her home and taught preschool at her church. She also facilitated a sponsorship program for families in a poorer section of her community. With the help of a few donors from the United States, fourteen children received food, soap, toothbrushes, and school fees on a monthly basis.

One mother of four told Nella, "After what Muslims have done to Christians, it is hard to receive help from you." She was referring to riots in which radical Muslims looted and burned churches and homes of Christians and the Chinese. Nella had fled to a neighboring island with more than 2,000 other believers, Chinese businessmen,

and others. Nella was among the first to leave but also the first to return. When she came home, her neighbors scolded, "Why did you leave? If that happens again, we will protect you." She decided to stay if there were future riots, but her Shepherd knew that would not happen.

One day, while Nella was teaching, she collapsed from head pain and was admitted to the hospital. As blood flowed out of her mouth and she gasped for breath, more than fifty people who loved Nella went to be with her. Many wept and prayed, but eight hours after she collapsed, she died from lung failure.

Nella's Shepherd had rescued her from a life of bold witness in a dark place, and now the tapestry of her life is etched with gold. Overlaying her life's beautiful pattern is a single shimmering line—the Crafter's finishing touch.

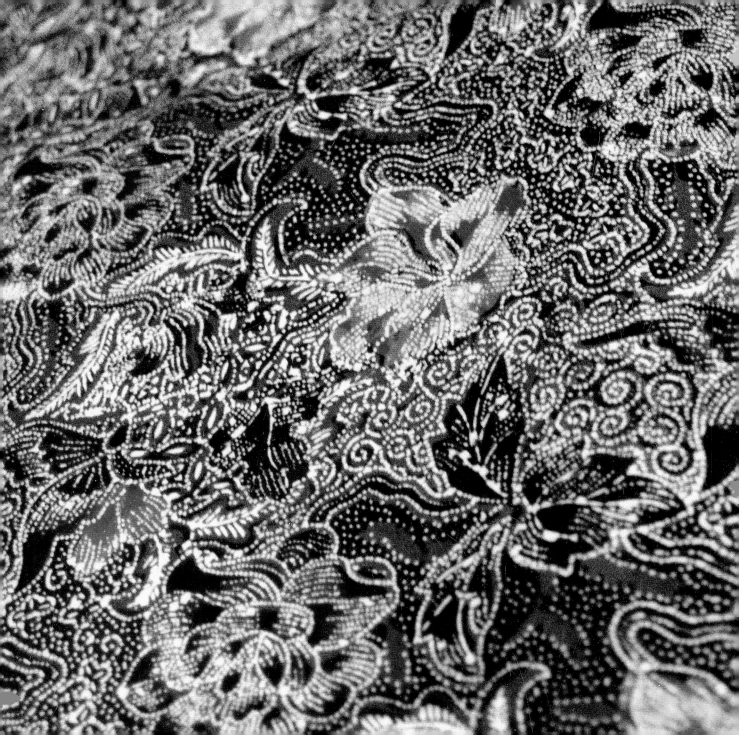

11. VENDOR: SACRIFICING TO SELL

From the artist who applies the wax to the employees who dip fabric into dye and skim melted wax from steaming water, batik is a process. But after the art is dried, pressed, and hemmed, one step remains. The beauty created would remain only marginally admired if it weren't for the batik seller.

"What color? What color?" cries the street vendor.

"What color are you looking for?" echoes the department store clerk with a bit more reserve.

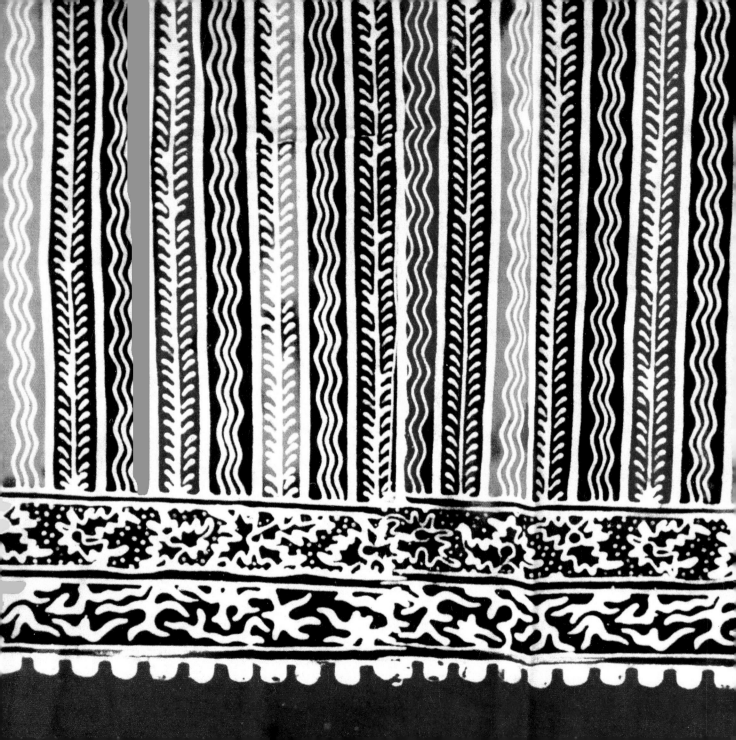

At the first mention of a color, or a slightly longer glance at a grouping of colors, the vendor unfolds pieces of batik. From bright oranges to bold blues, he loves to show his wares. The vendor's options may seem overwhelming, but he helps narrow the customer's choices as he promotes the uniqueness of each piece. He wants to make a sale, yes, but it is clear he also loves the cloth.

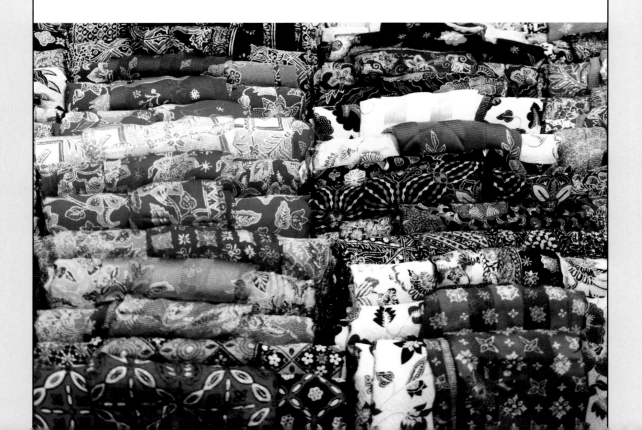

hasan

Hasan loves people. Like the batik seller, he never tires of sharing his love of Indonesia's people. Many of his fellow Indonesians have no idea who lives around them, so he meets regularly with professional groups and churches to help open their eyes. You see, Hasan knows what many don't. Of Indonesia's linguistic groups with more than 10,000 people, 127 have no Christian among them. Three to four hundred smaller linguistic groups also have no Christians.

Hasan's audiences often don't believe him—at least at first. As reality sinks in and Indonesian Christians discover the needs of the different cultures around them, Hasan gains friends who want to help influence these areas. Hasan would like to live

among these groups, but God has asked him to stay in Jakarta and mobilize others.

Hasan's life as a catalyst, however, came at a cost. His wife, Riya, had the opportunity to study city planning at Massachusetts Institute of Technology. Rather than take this full scholarship to success, she opted to stay in Indonesia and assist a businessman who wanted to inform others of the needs of these cultures without Christ.

As Riya networked with businesses and churches, Hasan caught the vision. When Riya resigned to stay home with their children, Hasan left the upper ranks of a chemical company and applied for her job. He wanted to stir Indonesian Christians to bring Christ to the forgotten ethnic groups around them. Not an hour after Hasan gave notice, his boss called from China. Since Hasan wasn't home, the man tried to convince Riya that her husband should

wait to become a missionary until he was 40 and had built a pension.

Despite this advice, the couple stuck to their decision, and they haven't looked back. Certainly their life would have been different had Riya opted for academic advancement or Hasan chosen the comfort of his career. And certainly life would be different for the cultures for which they have mobilized Christian workers.

The people of Indonesia, Christians in particular, are being stretched politically, spiritually, and economically. Hasan believes this is happening "that we might not rely on ourselves, but on God" (2 Corinthians. 1:9). As with the process of batik, the hard and hot things yield beauty. The faith of these batik believers is tested through the repeated stamps and unique writing of God's hand. Their culture dyes them as different. Yet when adversity, riots,

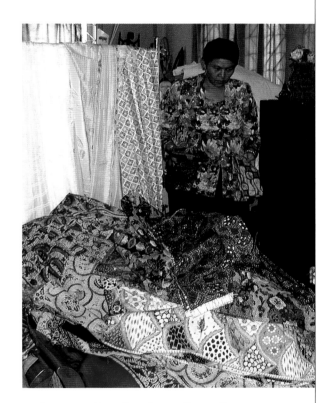

and persecution flood over them, they emerge beautiful—revealing a glimpse of the Artist's heart.

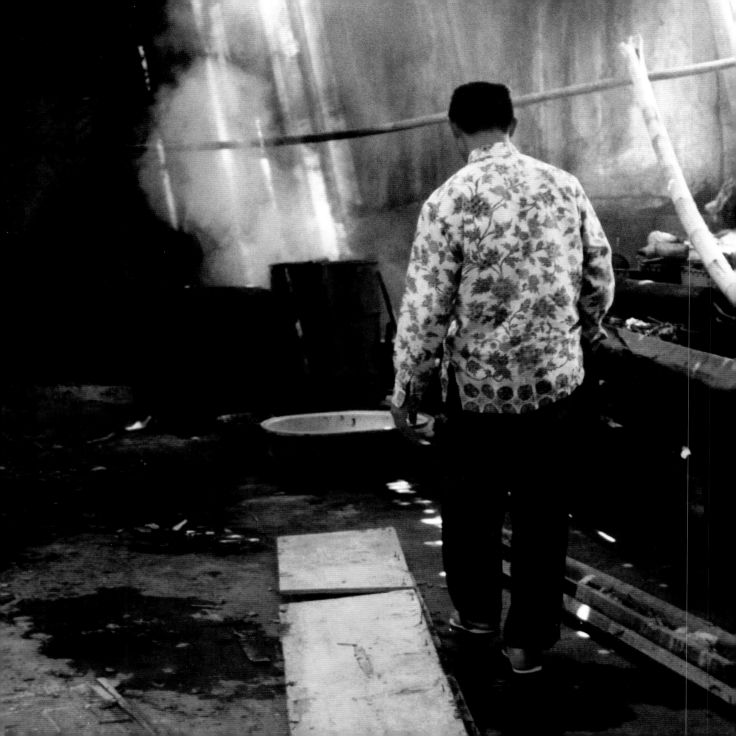

THE HEART OF PIONEERS

"What color? What color?" PIONEERS echoes the batik vendor.

What patterns capture your gaze?

Which people are pressed upon your own heart?

For more information visit our website at

www.pioneers.org

or call 407-382-6000

 PIONEERS